Mandala Coloring Book V.6

Boost Immune System

Andrea T. Cross

Copyright © 2019 Andrea T. Cross

All rights reserved.

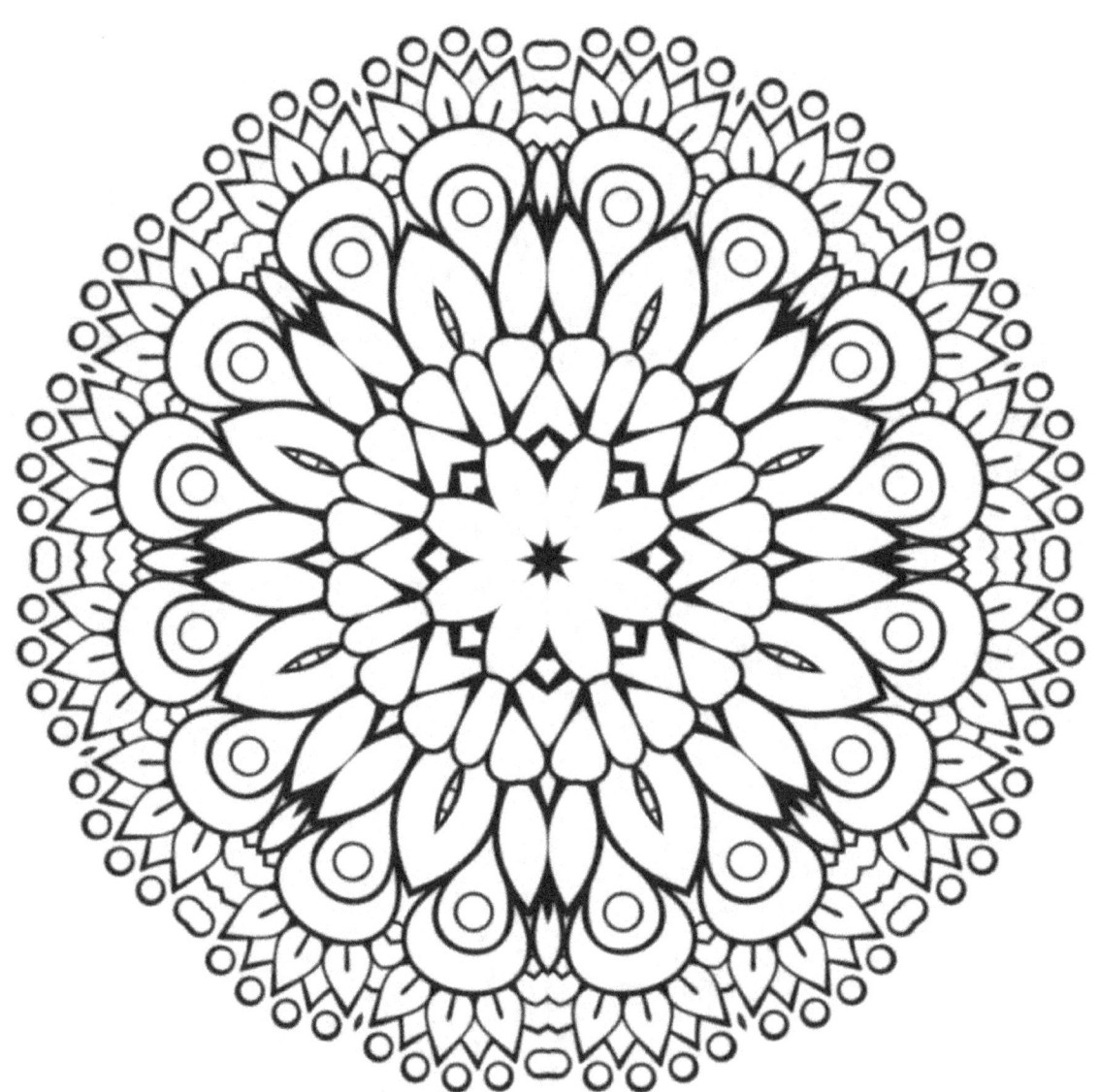

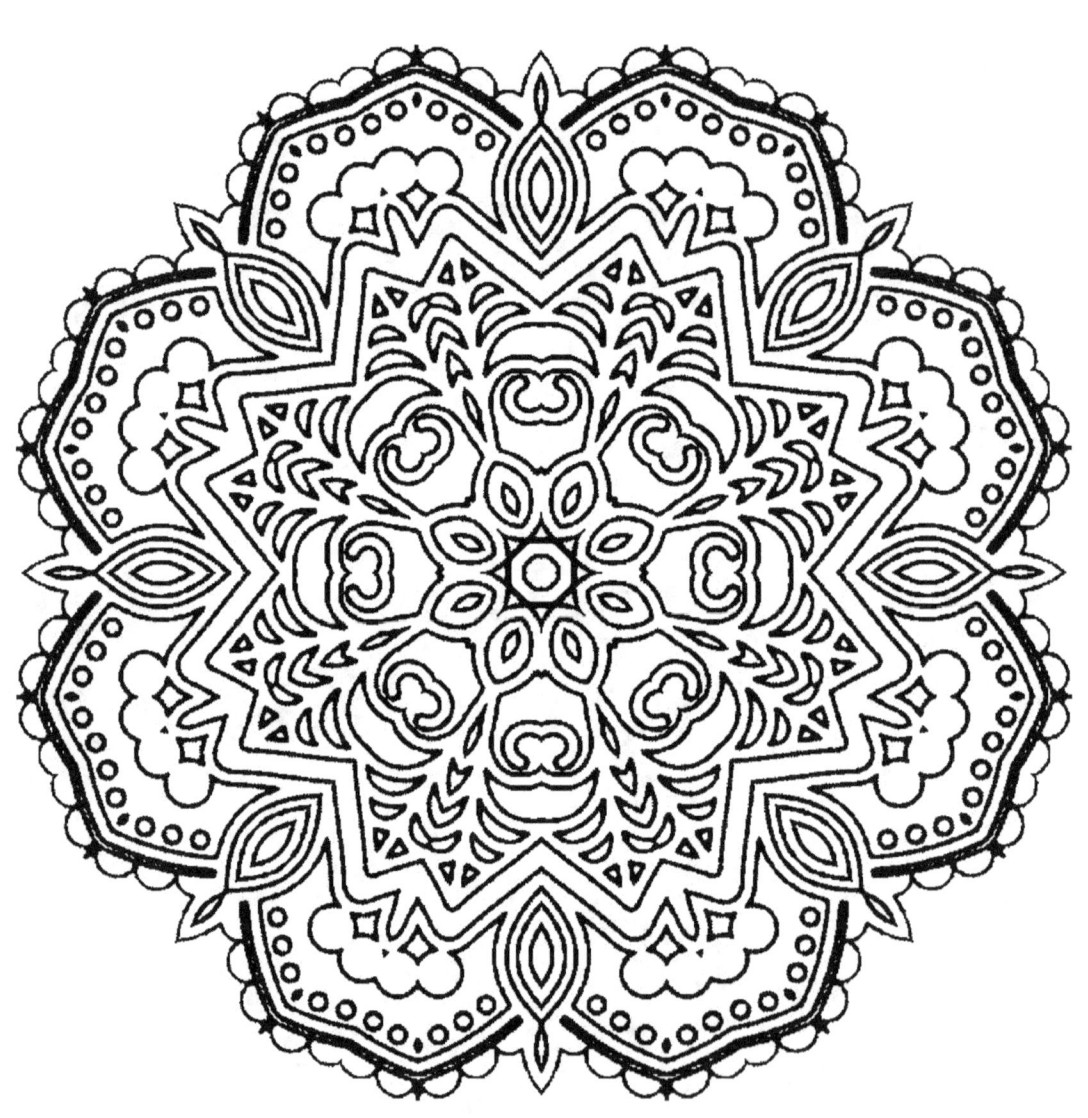

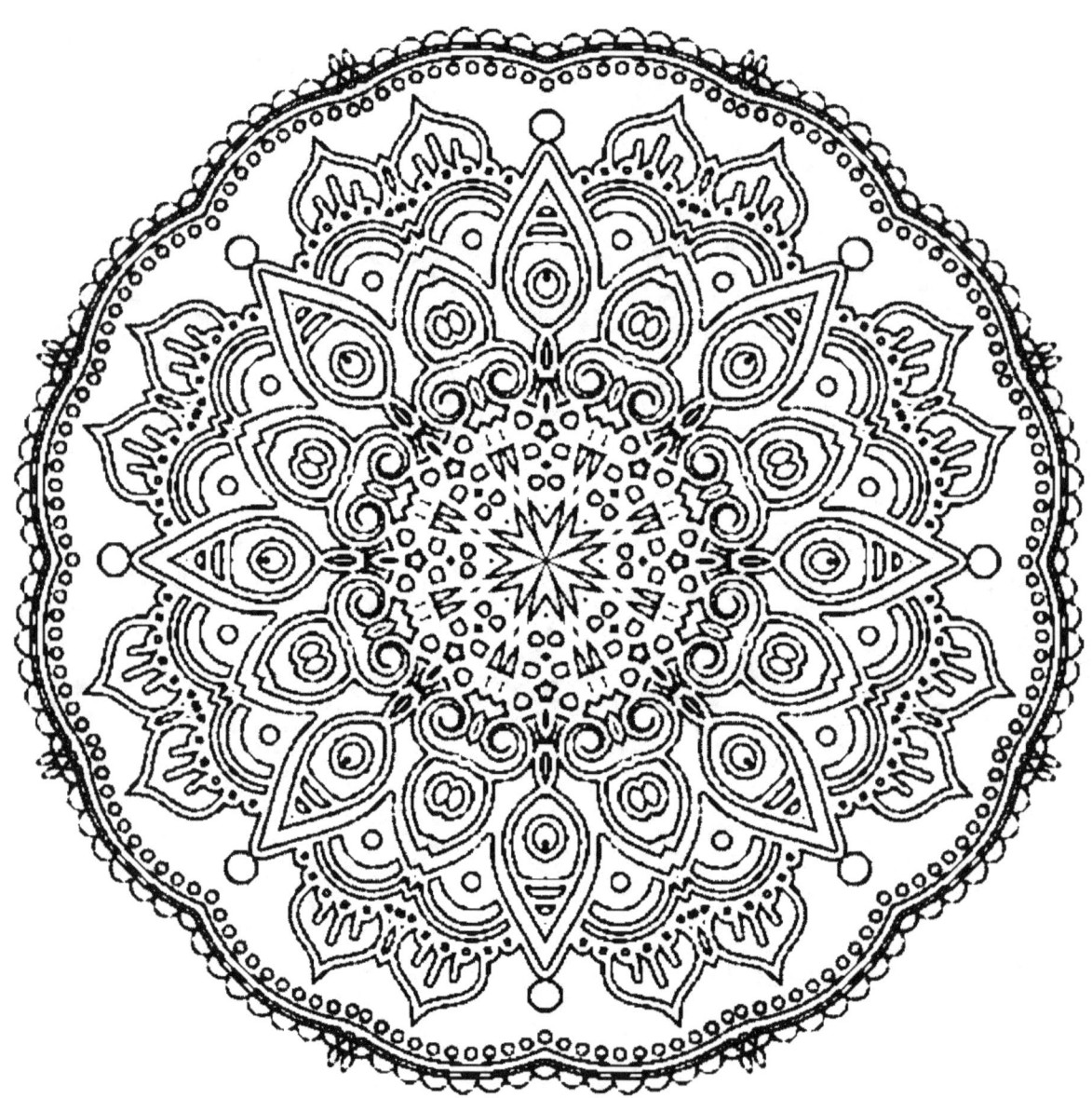

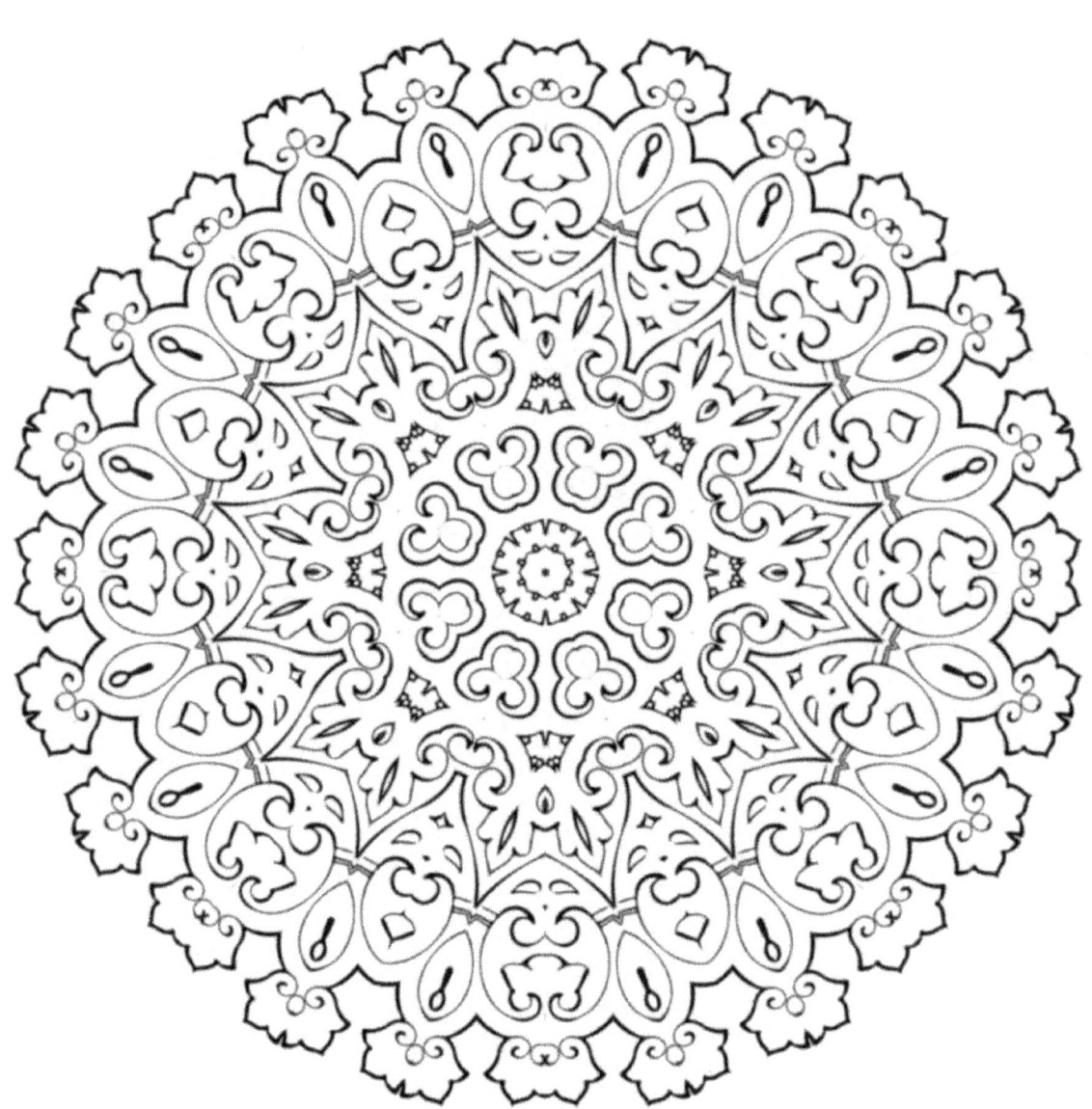

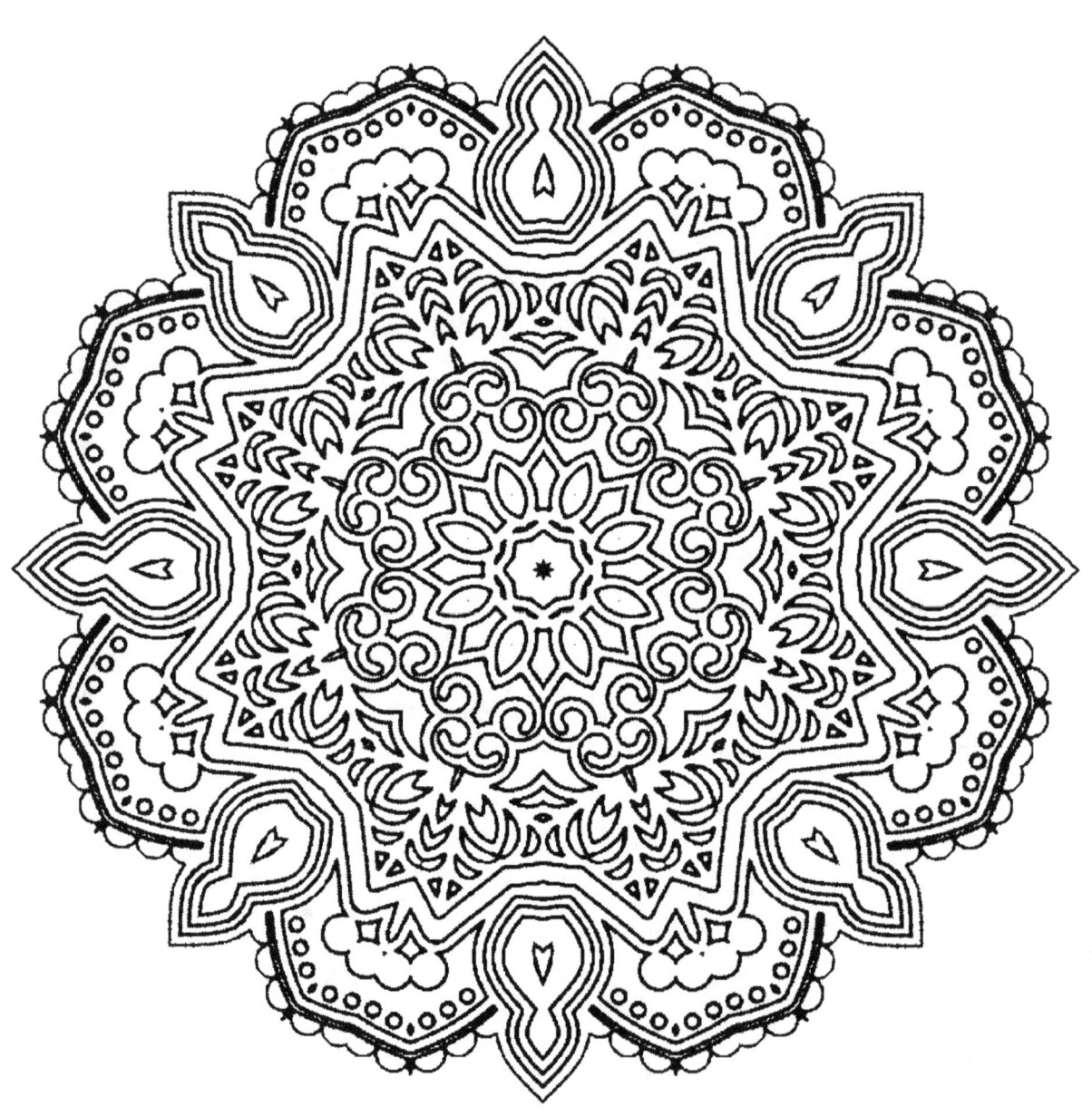

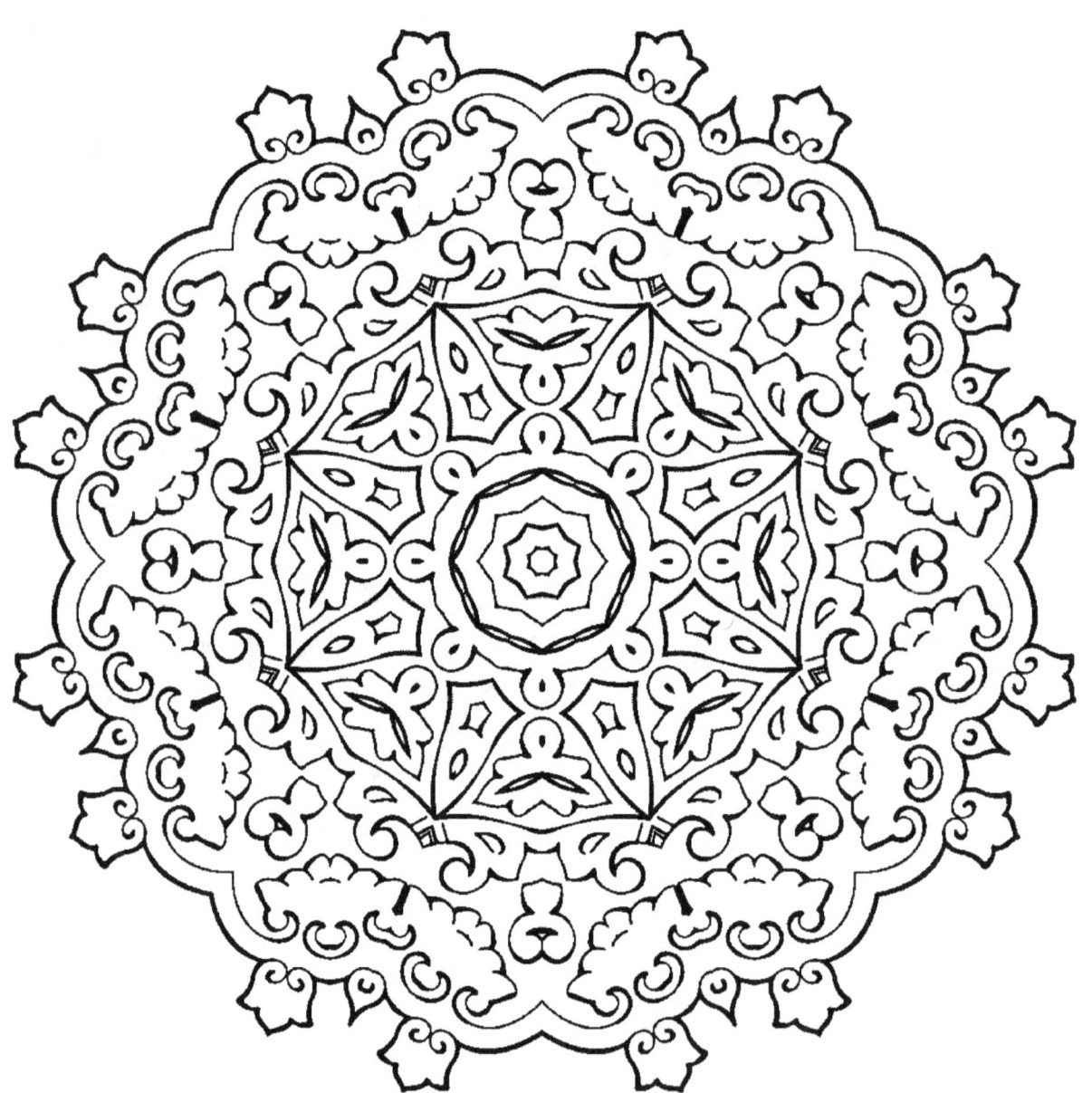

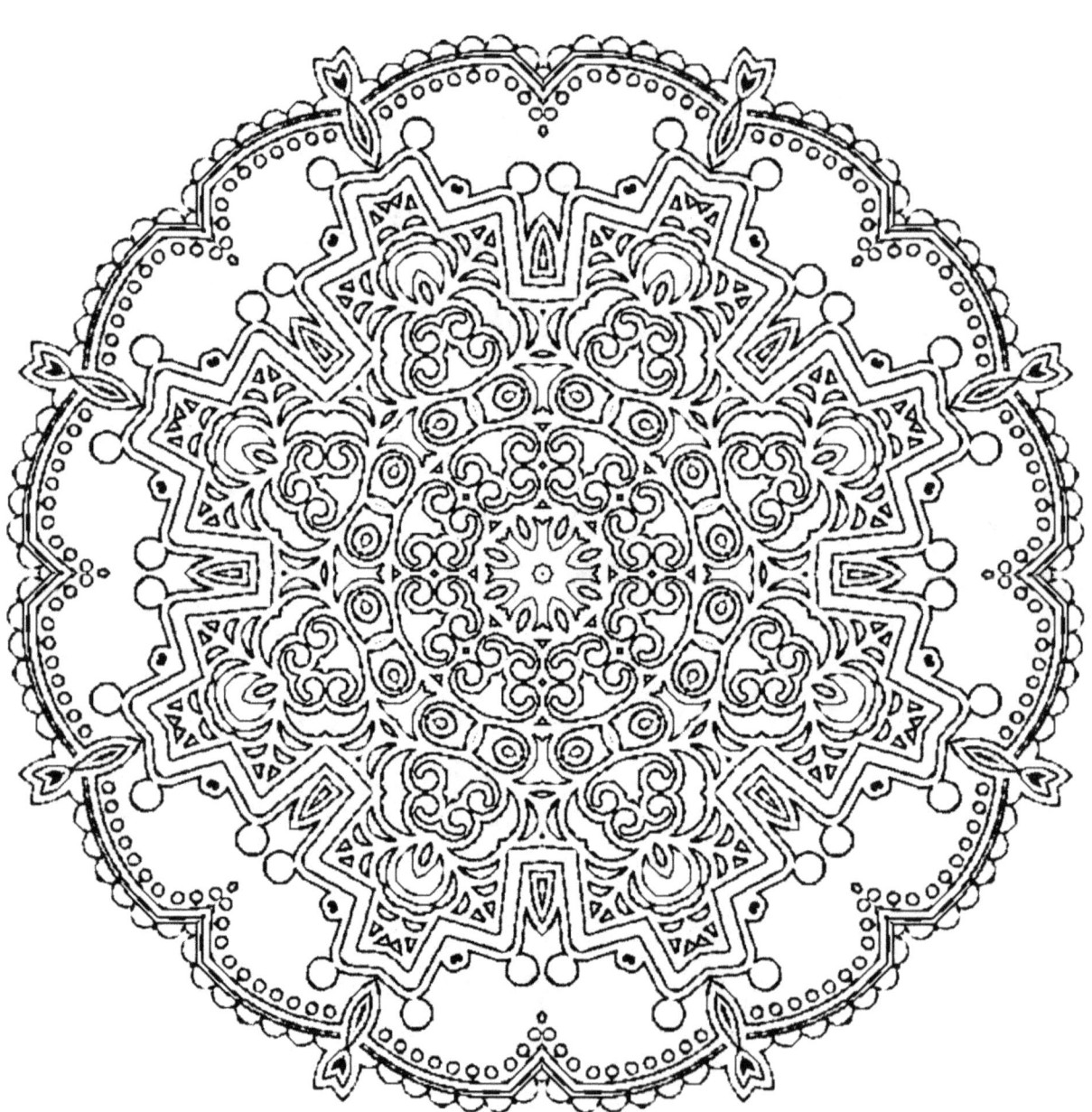